Thank you for cruising with us!

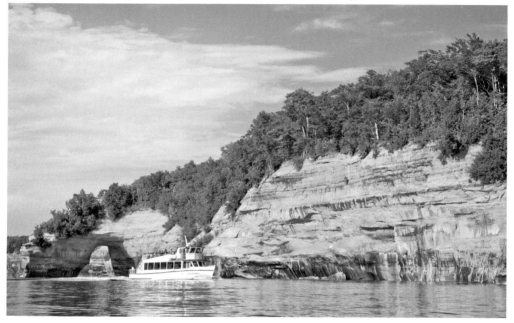

Pictured Rocks Cruises
100 West City Park Drive
Munising, Michigan 49862

(800) 650-2379 • (906) 387-2379

www.picturedrocks.com

Pictured Rocks Cruises Inc. is an authorized Concessioner of the National Park Service, Department of the Interior.

Cruise Boats a Part of Pictured Rocks History

*F*rom humble beginnings of a few visionary captains, Pictured Rocks Cruises now carries tens of thousands of people a year to enjoy Pictured Rocks National Lakeshore, the East Channel Lighthouse and Munising Bay. The first tours to operate along the Pictured Rocks Cliffs were aboard the Cleveland Cliffs Iron Company vessel the *Ottawa*, which left from Grand Island every Sunday during the 1920s. In 1939 and 1940 Pep Snyder operated the *Sea Queen*, while Claude Weikel operated the *Shamrock*, and John LeBoe piloted the 29 foot *Pictured Rocks I* and the 29 foot *Miss Palm Beach*, both speedboats that carried eleven passengers.

During World War II, operations were suspended, but in 1946 Everett Morrison began running tours on the *Sea Queen*. In 1947 he purchased the *Miss Palm Beach* and *Pictured Rocks I*. These boats were the beginning of the Pictured Rocks Cruises. Along with the *Tiger Lady* Morrison had the *Miss Munising* built in 1967. She was 61 feet long and carried 102 passengers. In 1974 the *Miners Castle* was purchased and a new Pictured Rocks Cruises partnership was established. In 1983 the *Miss Superior* was built and in 1987 the *Grand Island* was built by Shwartz Marine in Two Rivers, Wisconsin. The *Grand Portal* was built in Gulfport, Mississippi in 2004.

When Pictured Rocks National Lakeshore was established, Pictured Rocks Cruises, Inc. became an authorized concessioner of the National Park Service. As such, they work with the park to provide interpretive programming on all cruises. As the boats pass beneath sandstone cliffs, passengers learn about the geologic and human history of the area. Today's fleet of cruise boats provide indoor comfort as well as top-deck viewing. The cruises bring viewers close enough for wonderful photographic opportunities, pausing in the best locations long enough to snap a few memories or simply drink in the awe-inspiring artwork nature rendered.

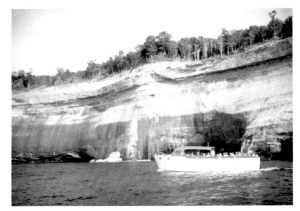

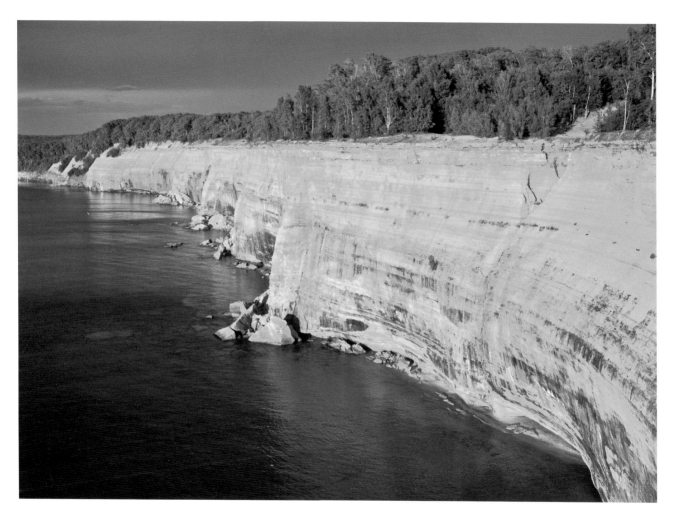

Cliffs between Miners and Mosquito Beaches

Plate 1

PICTURED ROCKS

From Land and Sea — Souvenir Edition

© 2012 Craig Blacklock — Revised 2021

ISBN 978-1-892472-25-0

Published by
Blacklock Photography Galleries
521 Folz Blvd., Moose Lake, MN 55767
www.blacklockgallery.com • 1-218-460-6351
Printed in Canada by Friesens—text paper FSC certified

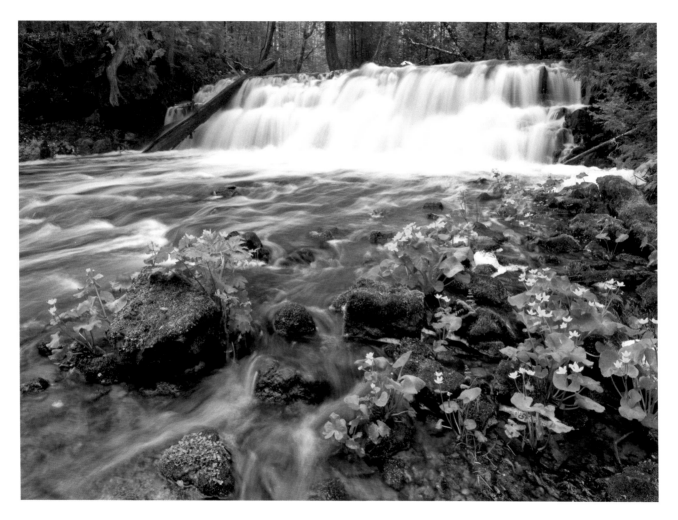

Mosquito Falls and marsh marigolds

Plate 2

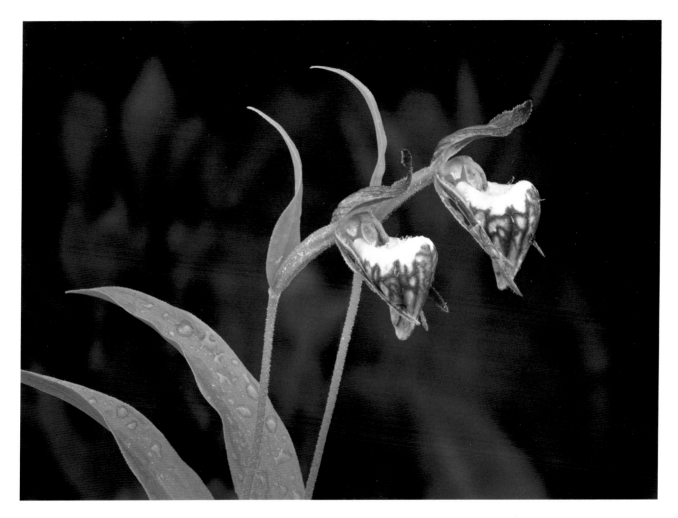

Ramshead orchids

Plate 3

Giant beech and maple trees, which protect a carpet of wildflowers in the spring, turn brilliant colors in the fall. Hidden within the forest, spectacular waterfalls punctuate rivers flowing down to sand beaches on Lake Superior. Along the Superior coast, two-hundred-foot-high cliffs of Cambrian period sandstone, deposited 500 million years ago, dominate Pictured Rocks. Water seeping through the sandstone dissolves minerals. Some of this mineral-laden water eventually runs down the cliff face, creating a continually changing tapestry. The red and brown stripes come from iron, black from manganese, turquoise and green from copper, and the yellows and white from limonite. Here and there, emerald-green moss adds additional color. It all stretches down to Superior's jade-green waters.

The cliffs have been eroded into interesting arches, caves, and pillars with descriptive names such as *Miners Castle*, *Lovers Leap*, and *Chapel Rock*. The other prominent geologic features of the park are the Grand Sable Banks and Dunes, which blanket five square miles at the park's eastern end. The dunes provide habitat for many plants found nowhere else in the park, and are well worth exploring.

Native American use goes back at least 4,600 years on Grand Island and 3,200 years in the Lakeshore. European fur trade, commercial fishing, logging, and shipping all impacted the area. Shipwrecks, the East Channel Lighthouse (privately owned on Grand Island), and the Au Sable Light Station are remaining evidence of these times. In 1966, Congress, recognizing the unique natural wonders of Pictured Rocks, established it as the nation's first National Lakeshore. Today it encompasses 73,236 acres. In 2009, an additional level of protection was given to the 11,740-acre Beaver Basin Wilderness.

My earliest photographs from Pictured Rocks date back to 1976. Working on this book allowed me to develop a deeper knowledge of areas I'd previously fallen in love with, and to discover new favorite places. I arranged the images in roughly the same way I feel most people discover the park—first viewing the inland flowers and waterfalls, then cruising the coastline from west to east, ending with the subtle beauty of the sand dunes. I hope my images will help keep your memories alive, allow you to better share stories with friends, lead you to seek new adventures—and above all, inspire you to work to protect our nation's natural and cultural heritage.

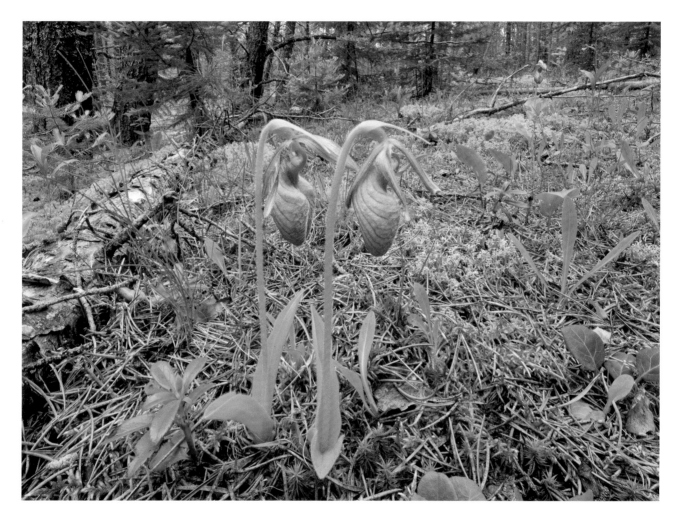

Stemless lady's-slippers and ramshead orchids

Plate 4

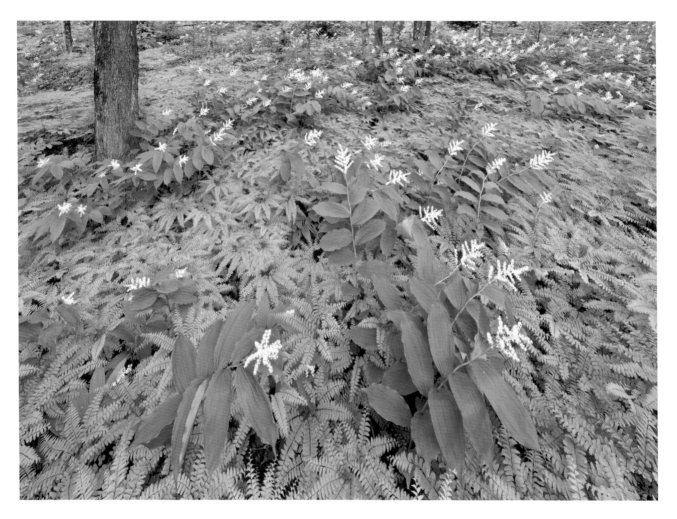

False Solomon's seal and maidenhair ferns

Plate 5

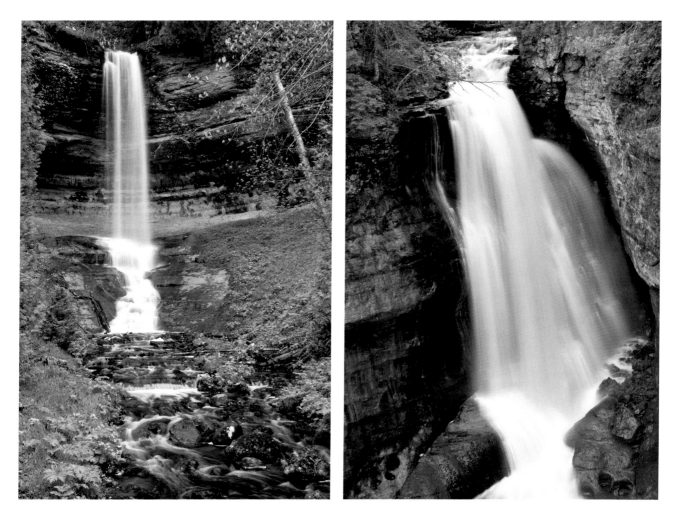

Munising Falls / Miners Falls

Plates 6, 7

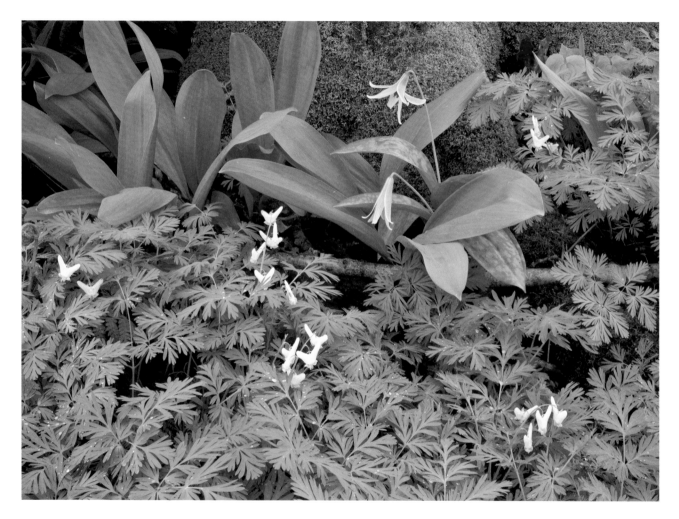

Yellow trout lilies and Dutchman's breeches

Plate 8

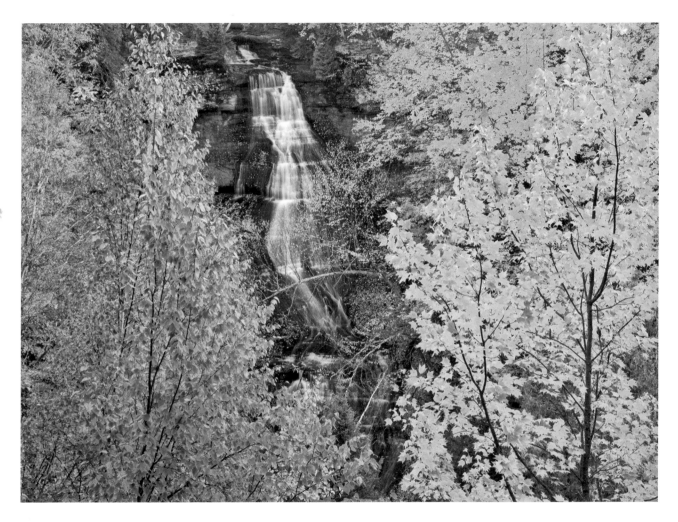

Chapel Falls

Plate 9

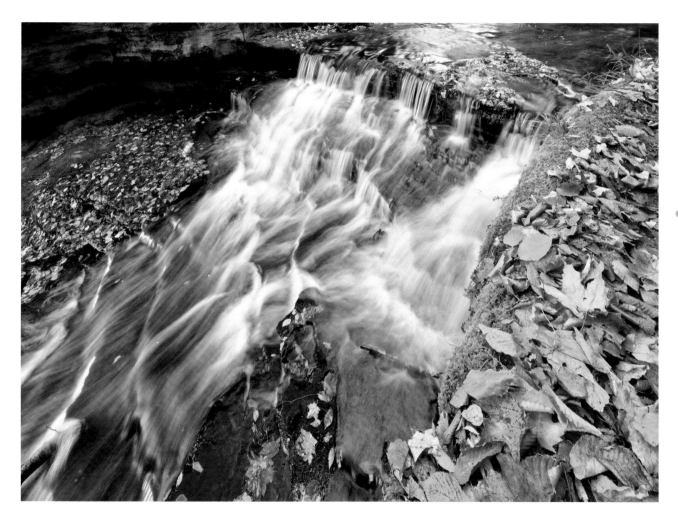

Chapel Falls

Plate 10

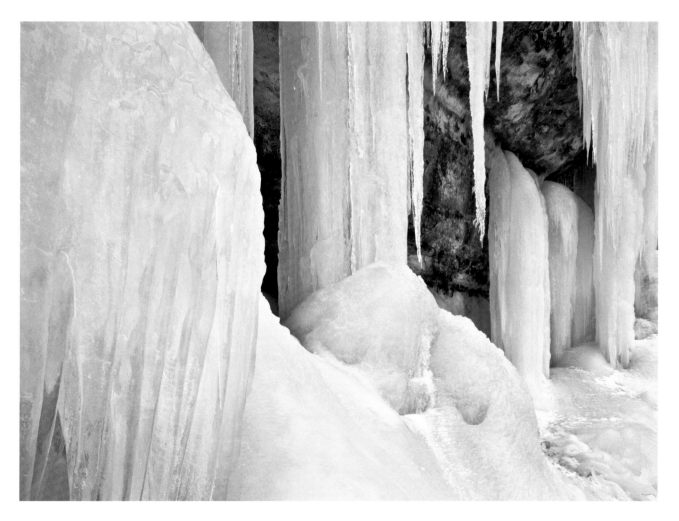

Ice formations, Sand Point

Plate 11

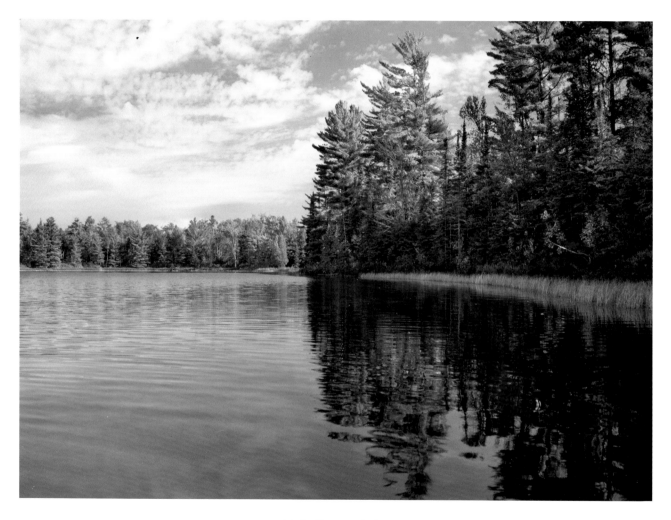

Little Beaver Lake

Plate 12

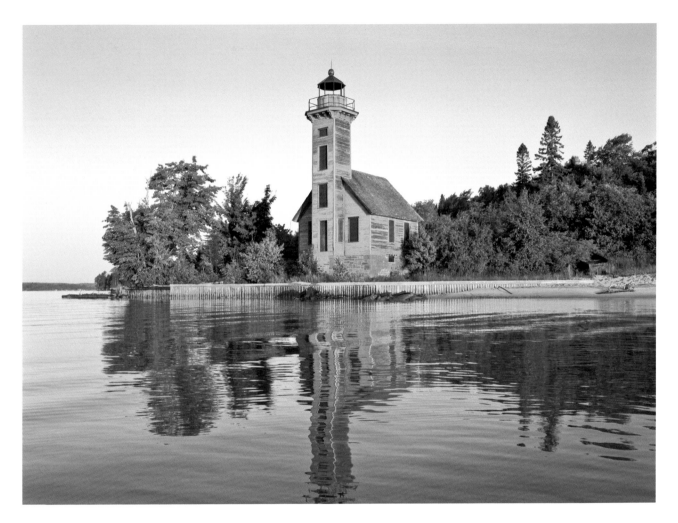

East Channel Lighthouse (privately owned on Grand Island)

Plate 13

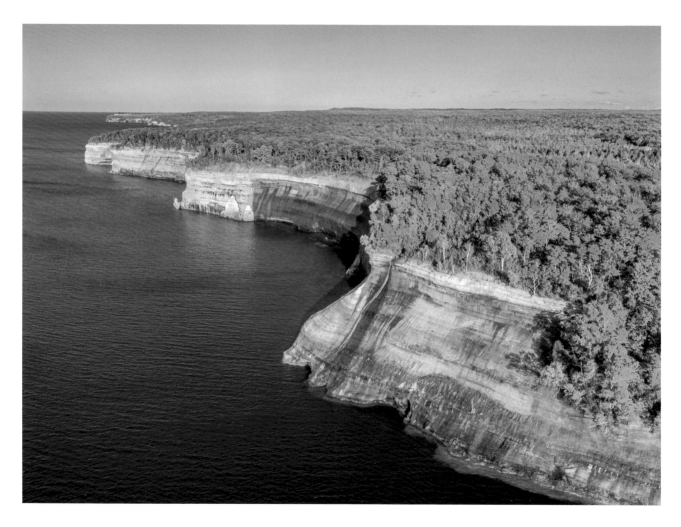

Bridal Veil Falls

Plate 14

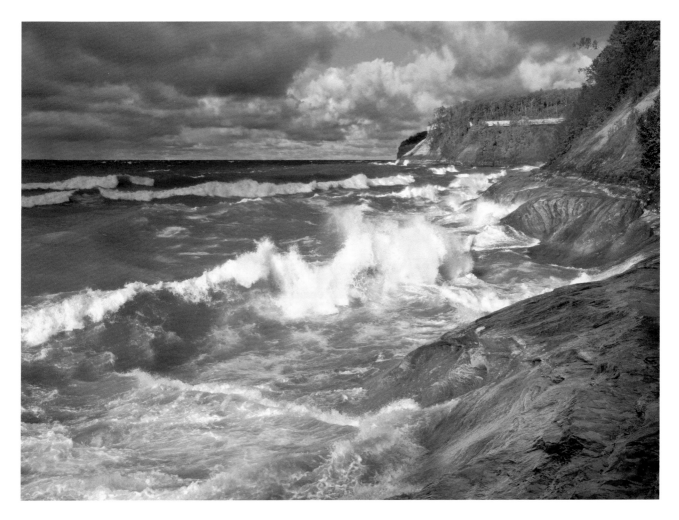

Surf, east of Miners Beach

Plate 15

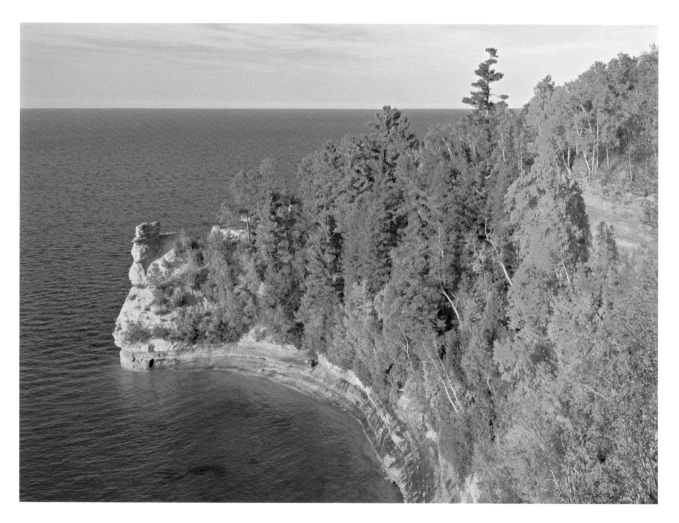

Miners Castle

Plate 16

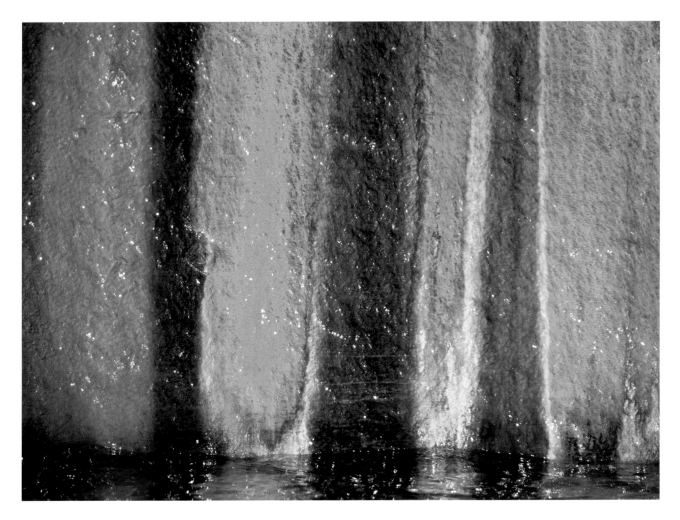

Mineral seep west of Mosquito Beach

Plate 17

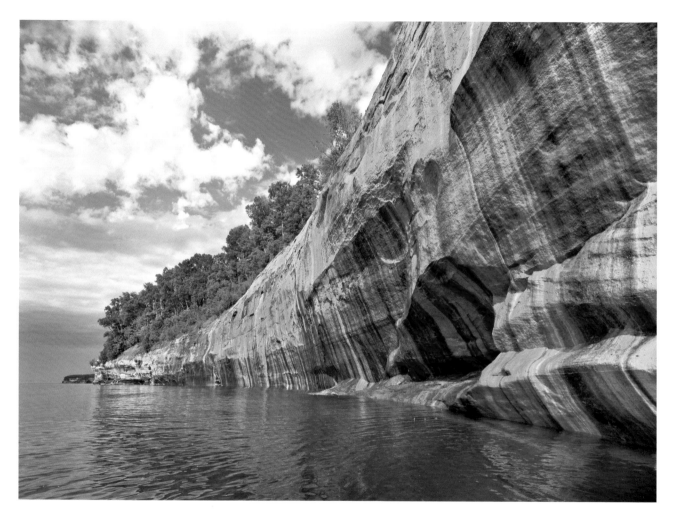

Cliffs between Miners and Mosquito Beaches

Plate 18

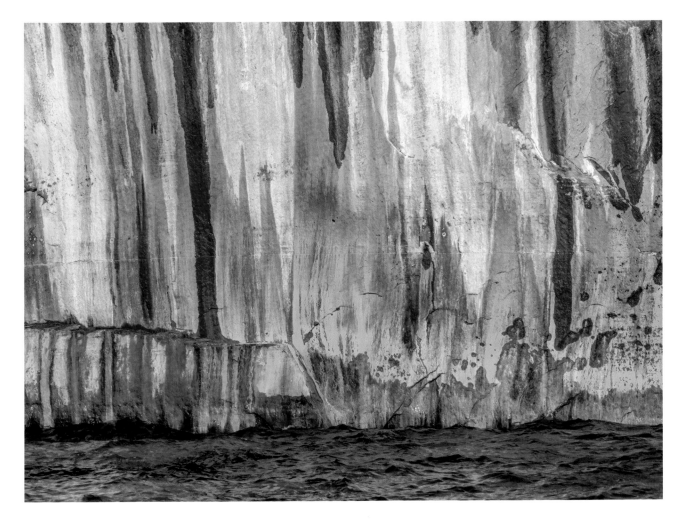

Mineral seep west of Mosquito Beach

Plate 19

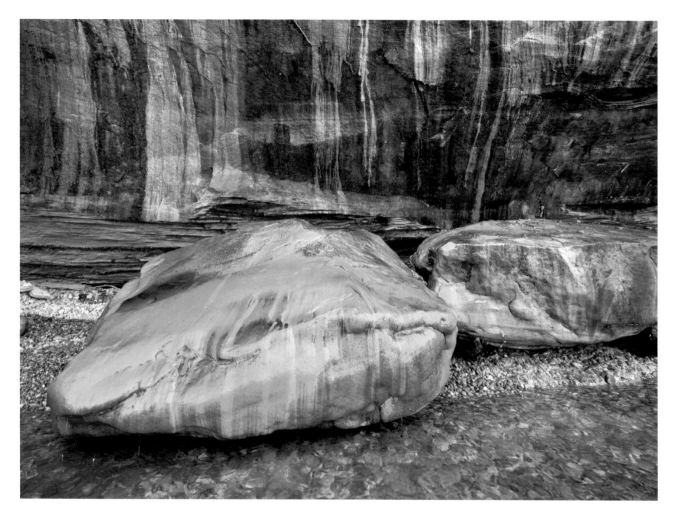

Mineral seep on boulders west of Mosquito Beach

Plate 20

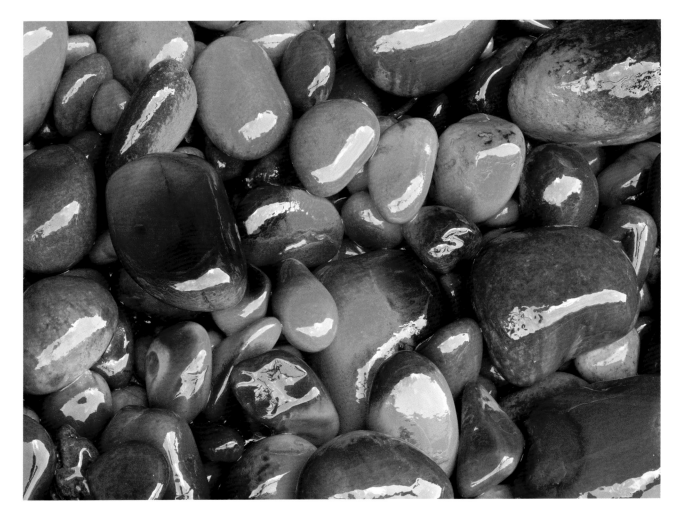

Mineral-stained stones, west of Mosquito Beach

Plate 21

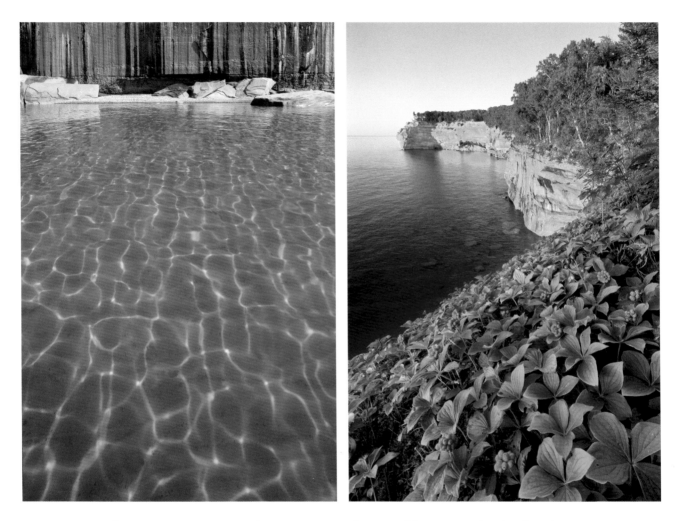

Refraction patterns west of Mosquito Beach / Bunchberries and Indianhead Point

Plates 22, 23

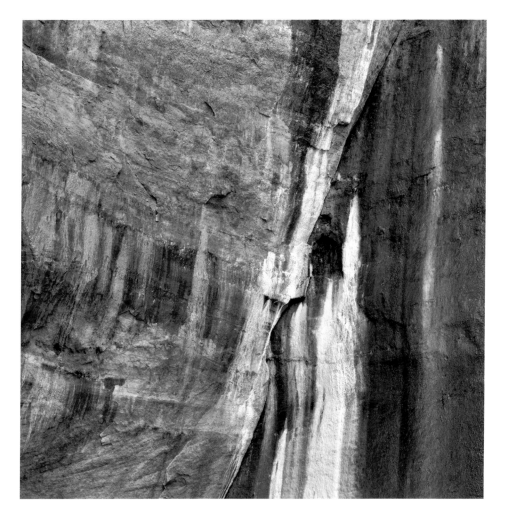

Mineral seep west of Mosquito Beach

Plate 24

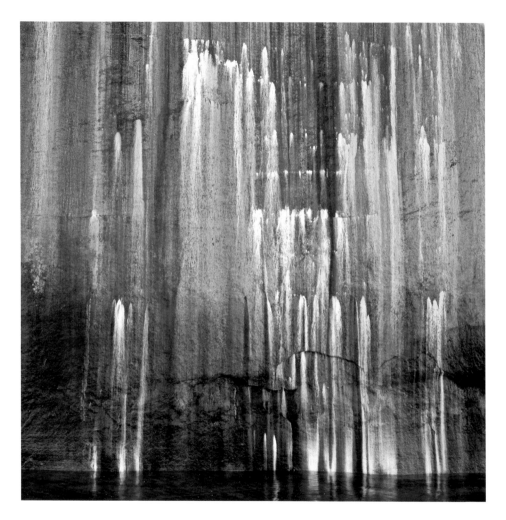

Mineral seep west of Mosquito Beach

Plate 25

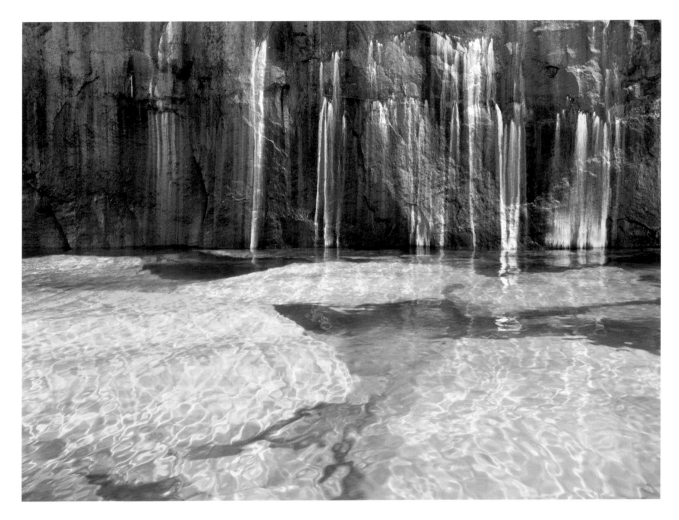

Mineral seep west of Mosquito Beach

Plate 26

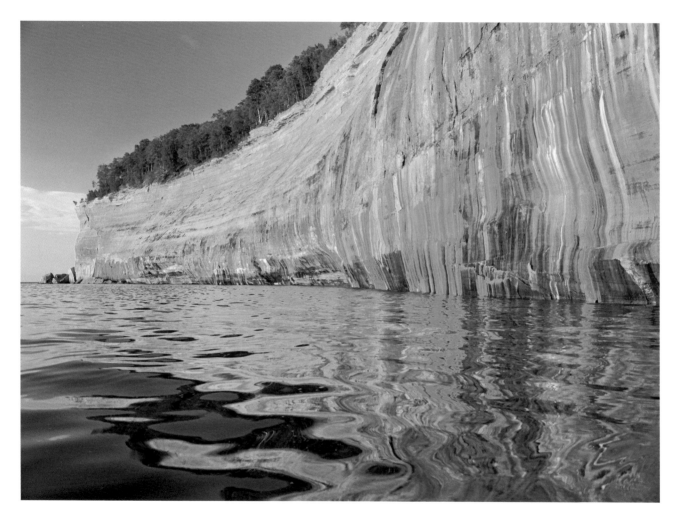

Mineral seep west of Mosquito Beach

Plate 27

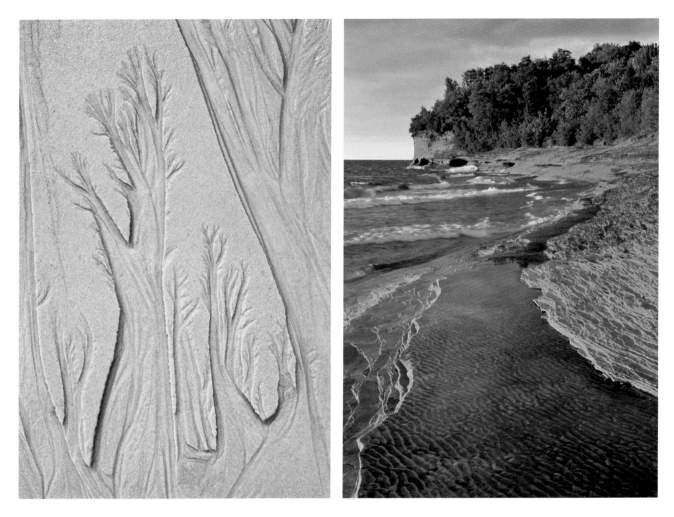

Erosion pattern in sand / Ripple marks in sandstone, Mosquito Beach

Plates 28, 29

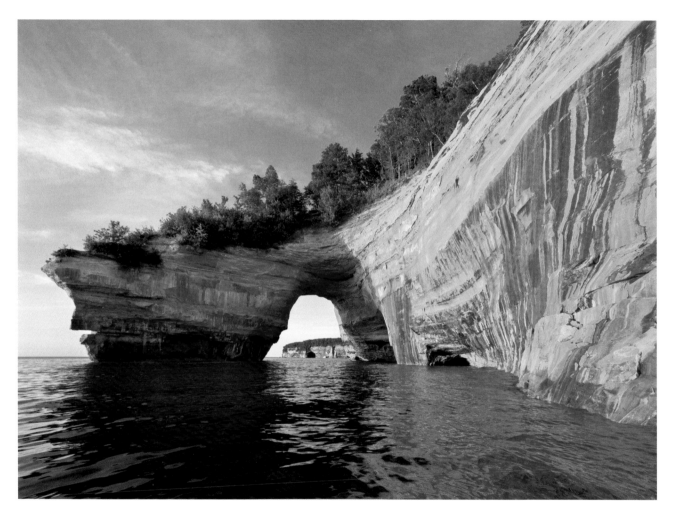

Lovers Leap

Plate 30

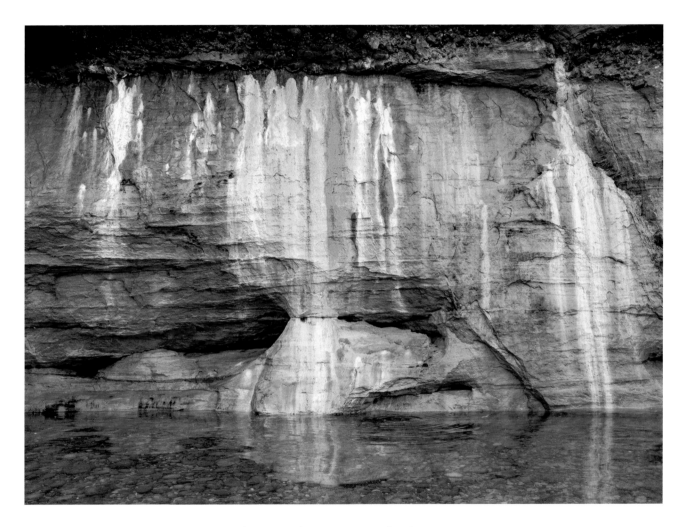

Mineral seep with turquoise color from copper

Plate 31

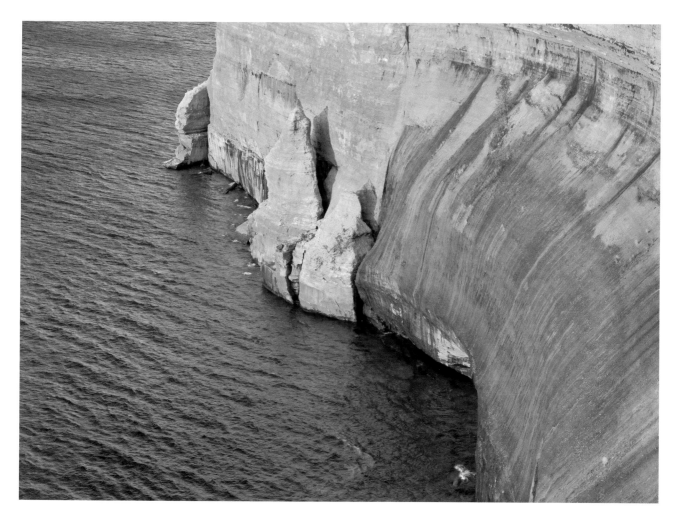

Mineral seep east of Miners Beach

Plate 32

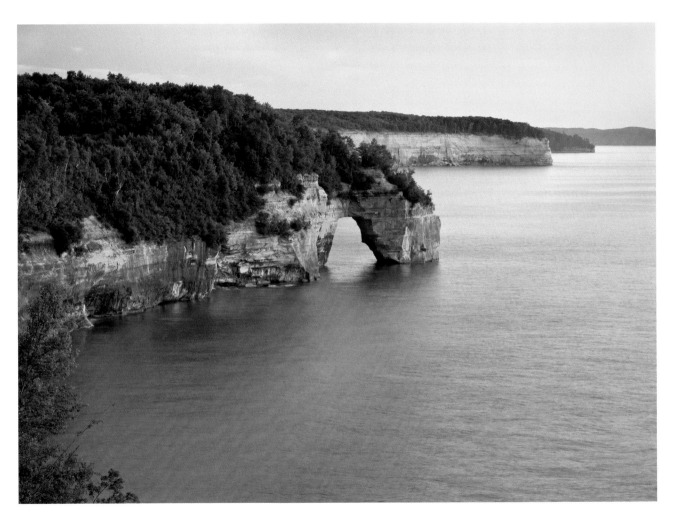

Lovers Leap

Plate 33

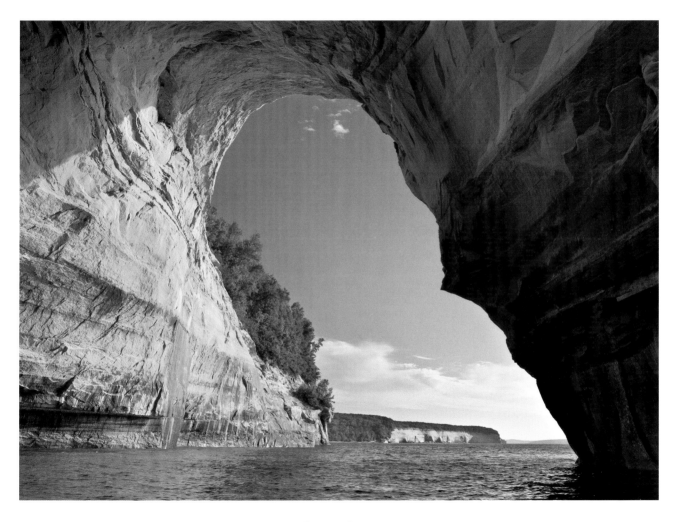

Lovers Leap

Plate 34

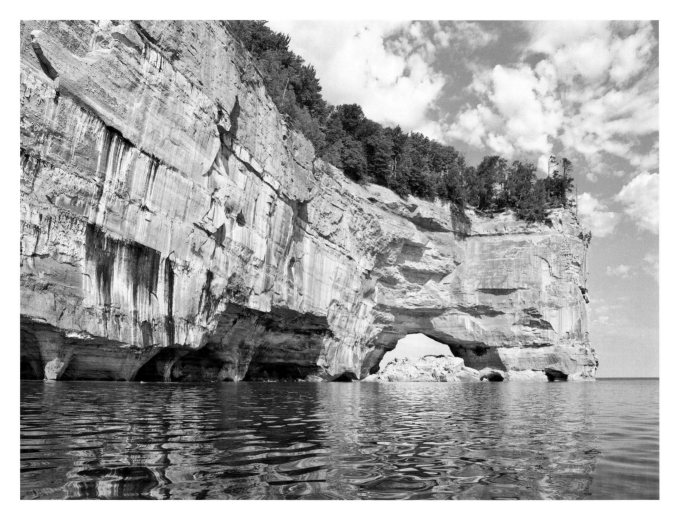

Grand Portal Point

Plate 35

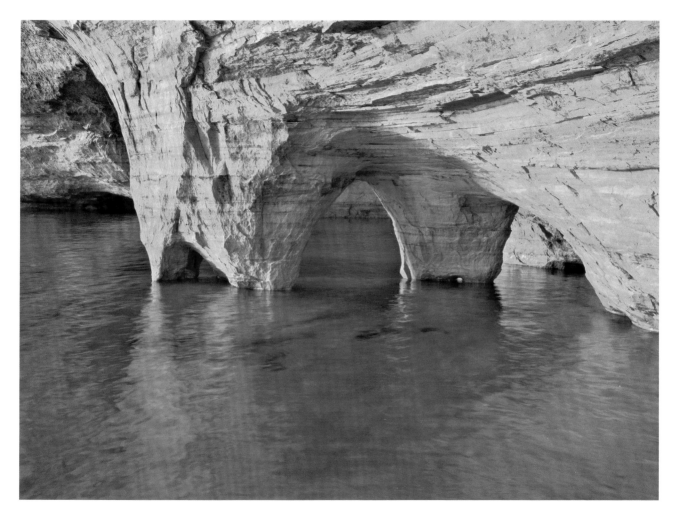

Small arches on Grand Portal Point

Plate 36

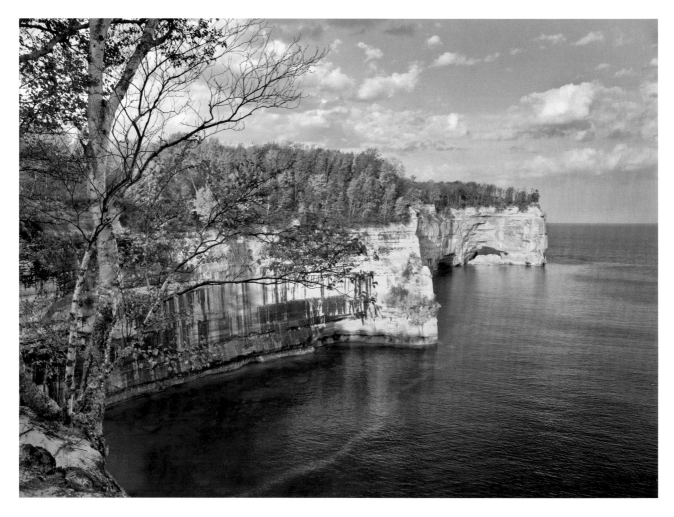

Grand Portal Point

Plate 37

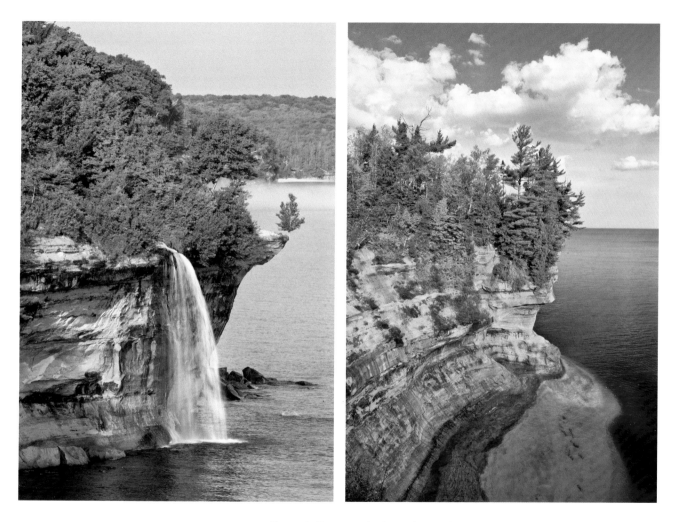

Spray Falls / Cliff west of Chapel Beach

Plates 38, 39

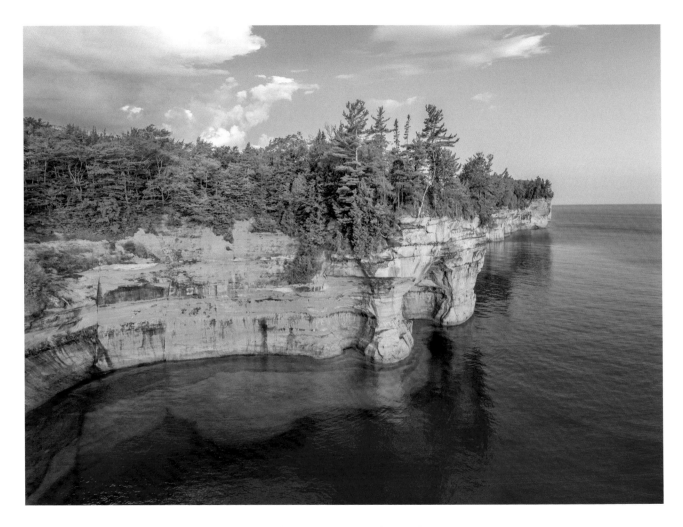

Cliffs west of Chapel Beach

Plate 40

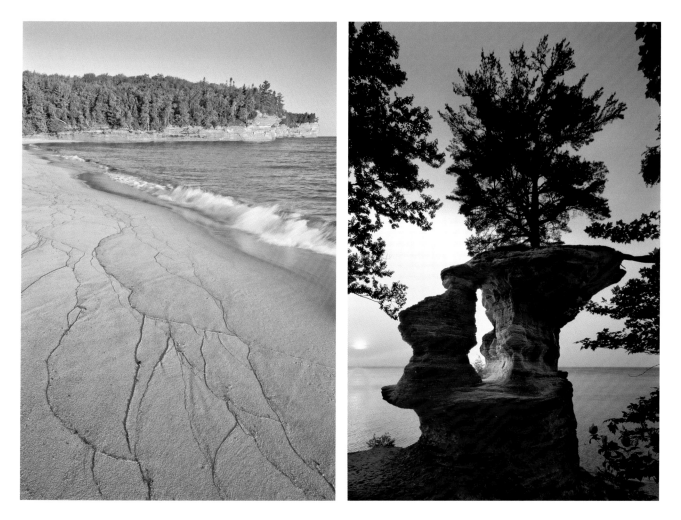

Chapel Beach / Chapel Rock

Plates 41, 42

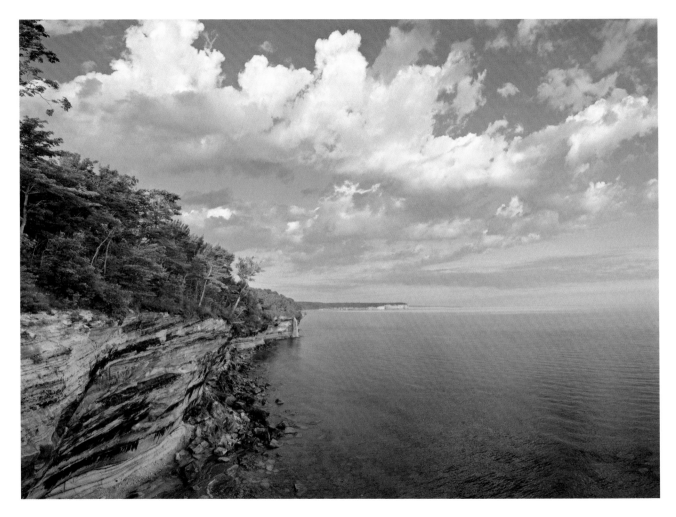

Spray Falls

Plate 43

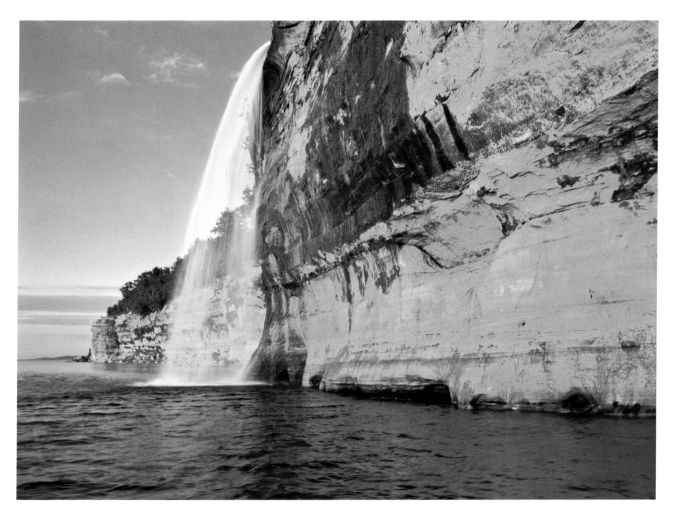

Spray Falls

Plate 44

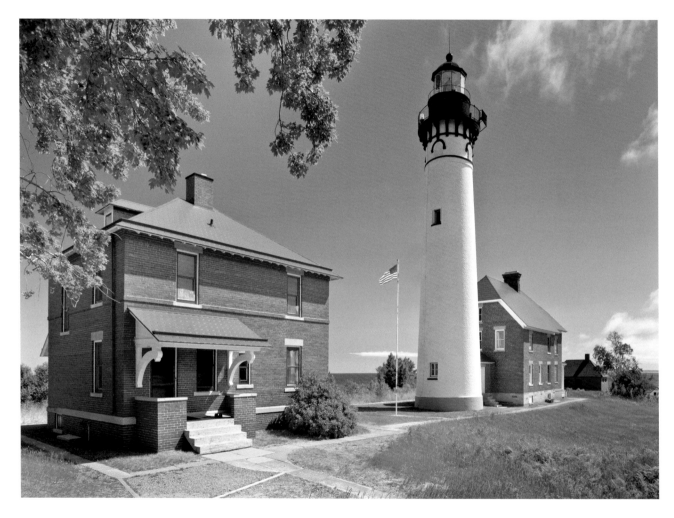

Au Sable Light Station

Plate 45

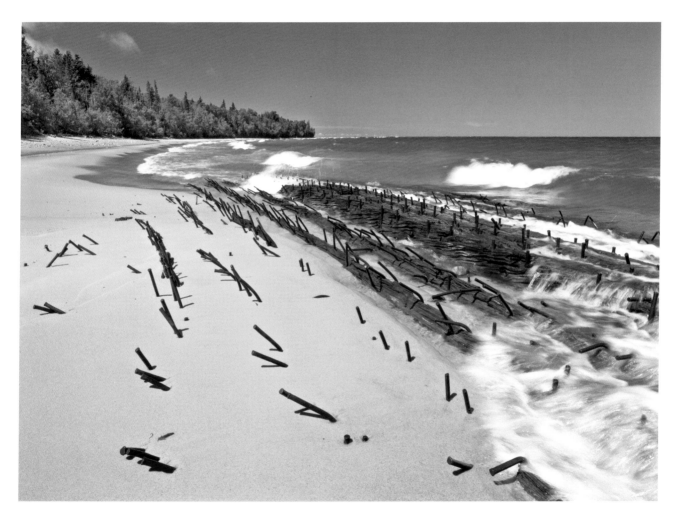

Shipwreck, Au Sable Point

Plate 46

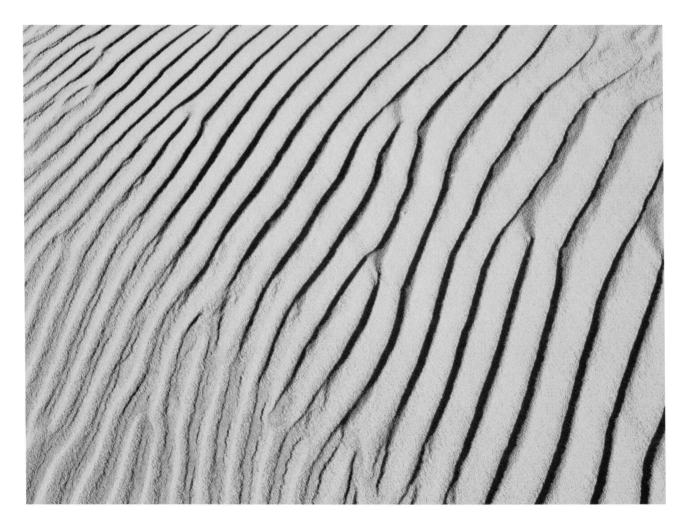

Wind-patterned sand, Grand Sable Dunes

Plate 47

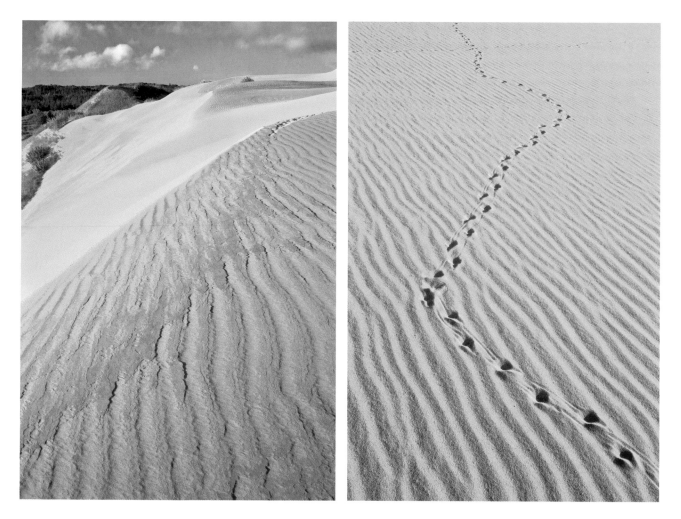

Wind-patterned sand / Bird tracks, Grand Sable Dunes

Plates 48, 49

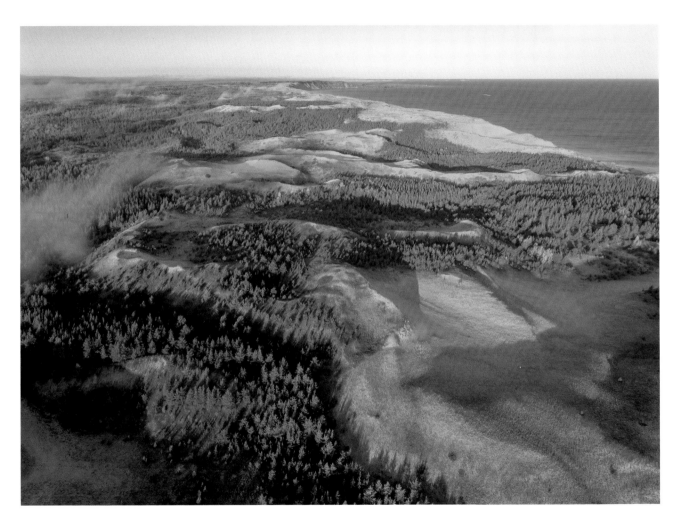

Grand Sable Dunes

Plate 50

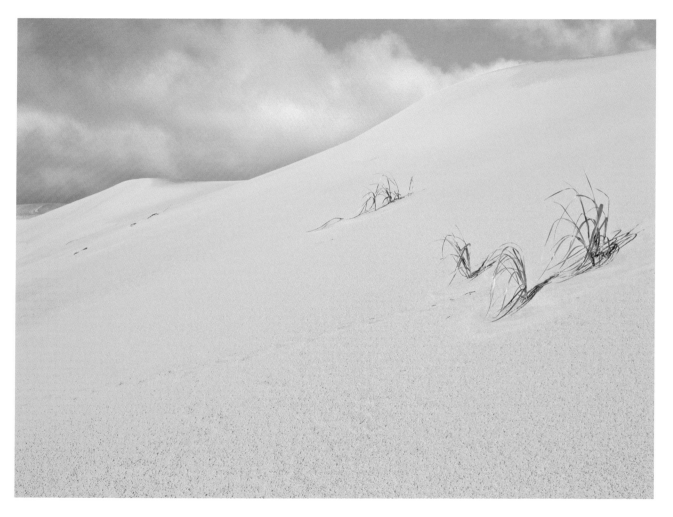

Grand Sable Dunes

Plate 51

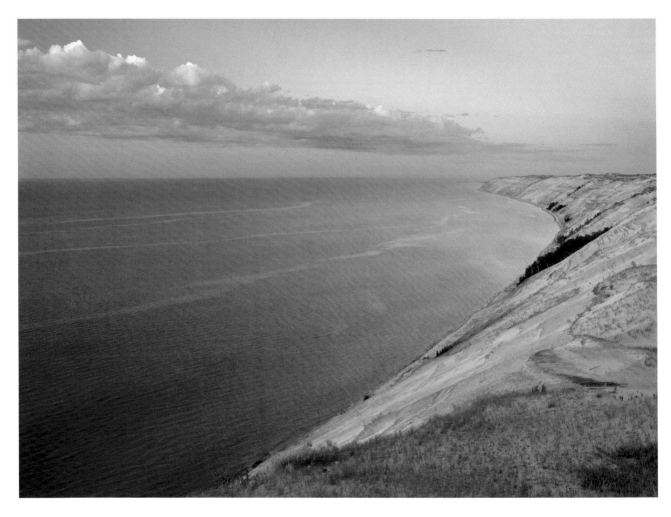

Late light on Grand Sable Banks

Plate 52

Alger County Chamber of Commerce
Fuzzy Boyak Welcome Center
129 E. Munising Ave,
Munising, MI

(906)387-2138

For more information when making your travel plans to Pictured Rocks National Lakeshore and the surrounding area visit algercounty.org.

 Alger Falls Motel
and Cottage Rentals
906-387-3536
algerfallsmotel.com

 Hillcrest Motel & Cabins
906-387-6363
hillcrestmotelandcabins.com

Sunset Motel on the Bay
906-387-4574
sunsetmotelonthebay.com

 AmericInn
906-387-2000
americinnmunising.com

 Holiday Inn Express
906-387-4800
hiexpressmunising.com

Superior Motel
&
Suites
Superior Motel & Suites
906-387-1600
superior-motel.com

 Beach Inn Motel
on Munising Bay
1-855-255-1902
beachinnmunisingbay.com

 Munising Motel
906-387-3187
munisingmotel.com

 Terrace Motel
906-387-2735
terracemotel.net

 Buckhorn Resort
906-387-3559
buckhornresort.com

 Scotty's Motel
906-387-2449
munising.org/
munisinglodging/scotty's

 Roam Inn
(906) 387-8000
roam-inn.com

 Comfort Inn & Suites
(906)387-6600
choicehotels.com

 North Star Hotel
Pictured Rocks
(906) 387-2493
picturedrocksinn.com

Pictured Rocks
Inn & Suites
906-387-2493
picturedrocksinn.com

 Borders Inn & Suites
906-387-5292
boardersinnandsuitesmunising.com

EconoLodge Inn and Suites
906-387-4864
cherrywoodlodgemunising.com

DATE DUE

206	MAY 16		
206	NOV 14		
206	FEB 06		
206	B 12		
205	NOV 20		
206	OCT 07		
206	MAR 23		

WILL IT EVER BE MY BIRTHDAY?

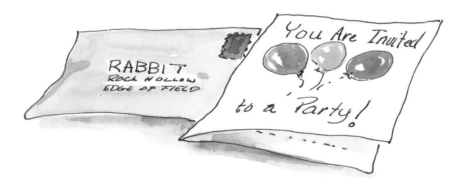

To my own little rabbit. *D.C.*

Library of Congress Cataloging-in-Publication Data

Corey, Dorothy.
 Will it ever be my birthday?

 Summary: As the seasons pass and he attends his friends'
birthday parties, Rabbit waits impatiently for his own
birthday to come again.
 [1. Birthdays—Fiction. 2. Parties—Fiction.
3. Seasons—Fiction. 4. Rabbits—Fiction. 5. Animals—
Fiction] I. Christelow, Eileen, ill. II. Title.
PZ7.C815395Wi 1986 [E] . 86-1565
ISBN 0-8075-9106-8

WILL IT EVER BE MY BIRTHDAY?

Dorothy Corey

pictures by Eileen Christelow

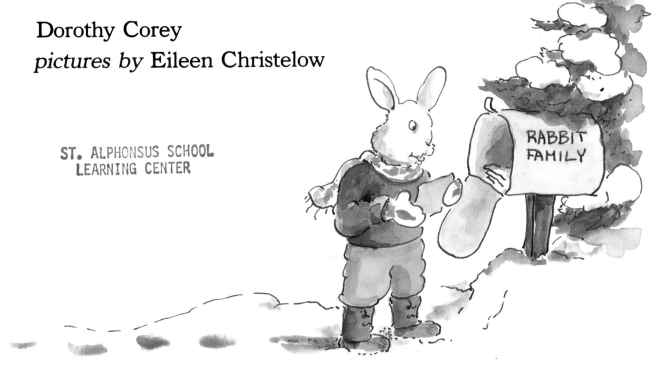

Albert Whitman & Company, Niles, Illinois

Rabbit looked at the letter the mail lady had left in his mailbox. It was an invitation to his friend Bear's birthday party.

"Do I have to go?" he asked his mother.

"Rabbit dear," she said, "Bear is your friend. Friends go to each other's parties. Bear came to your birthday party last October. Remember?"

"That was ages ago," said Rabbit.

"Less than four months," said Mother Rabbit. "Besides, you enjoy birthday parties."

"I enjoy *my* birthday parties," said Rabbit.

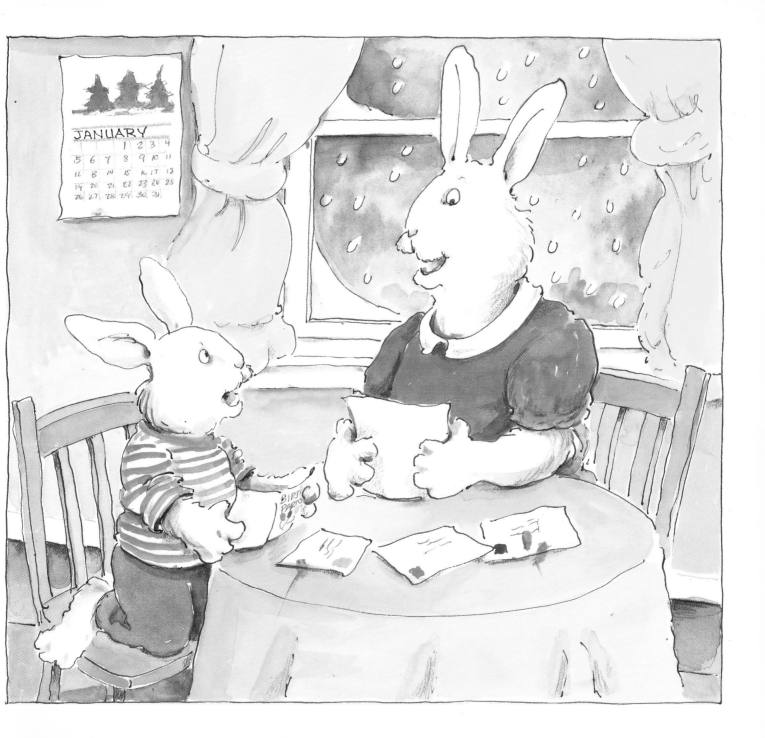

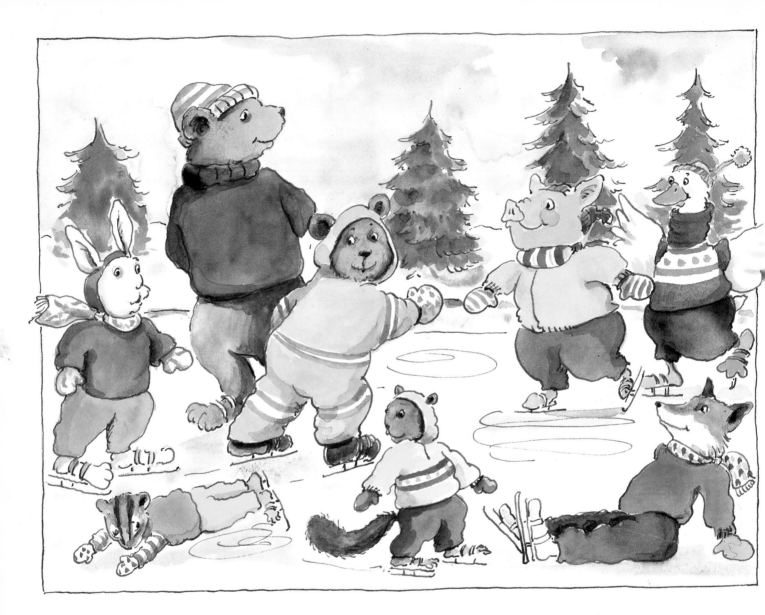

Rabbit did go, of course. Bear had a fine party. First Father Bear took everyone ice-skating.

Then the guests went to Bear's warm house to enjoy the honey cake Aunt Bear had baked.

Rabbit didn't have much fun. He barely sang "Happy Birthday." "Why can't it be *my* party?" he wondered.

He had brought Bear a flashlight, but he wanted to take it back.

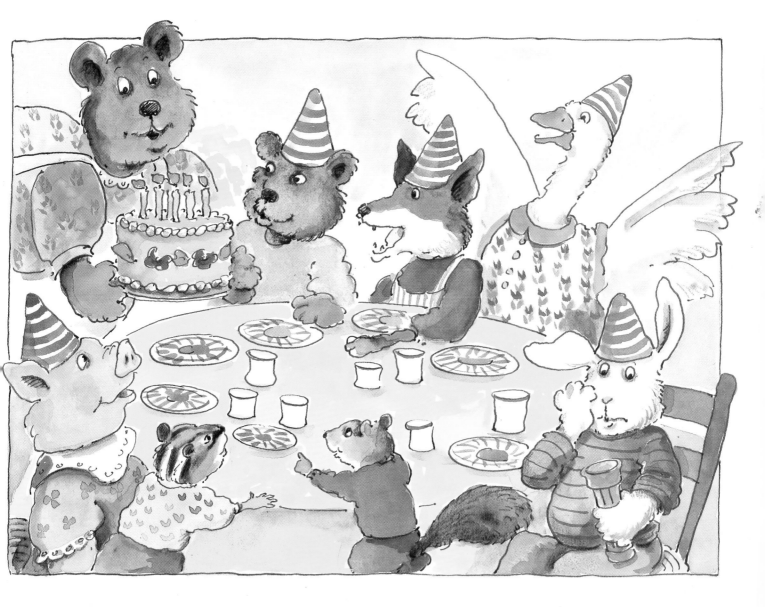

In February Rabbit got an invitation to Fox's birthday party.

"I guess I'll have to go," he said. He made up a little song. *"Winter, spring, summer, fall. I can't wait for my birthday. I can't wait at all."*

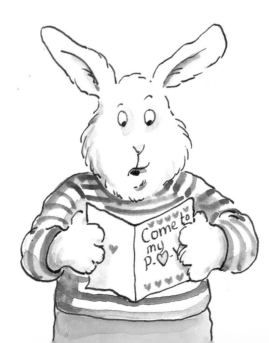

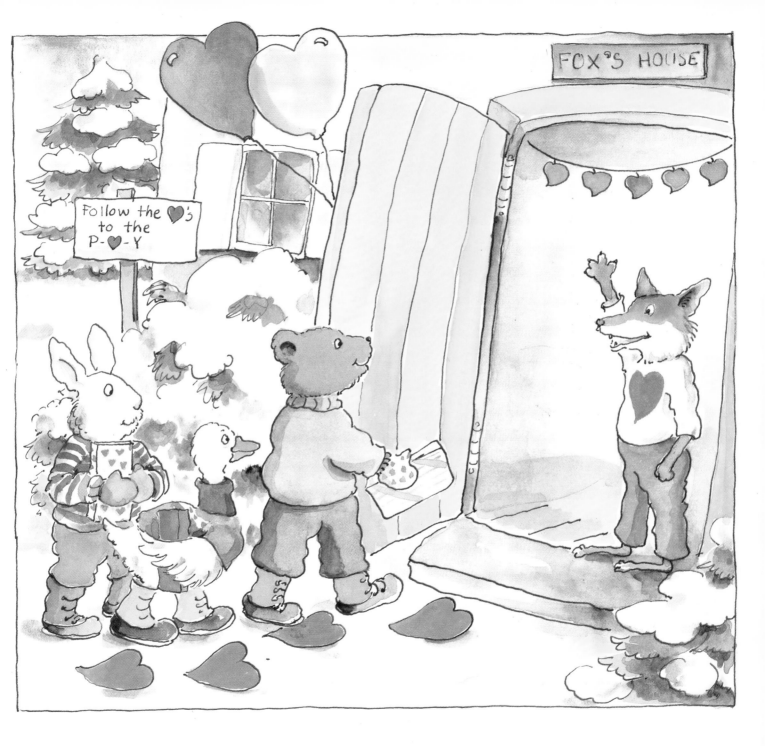

Fox had a heart-y party. Hearts were everywhere. The whole Fox family had hidden candy hearts for the guests to find. Sister Fox had made a heart-shaped cake.

Fox got lots of presents with hearts on them.

"Hearts are dumb," said Rabbit. But secretly he liked them.

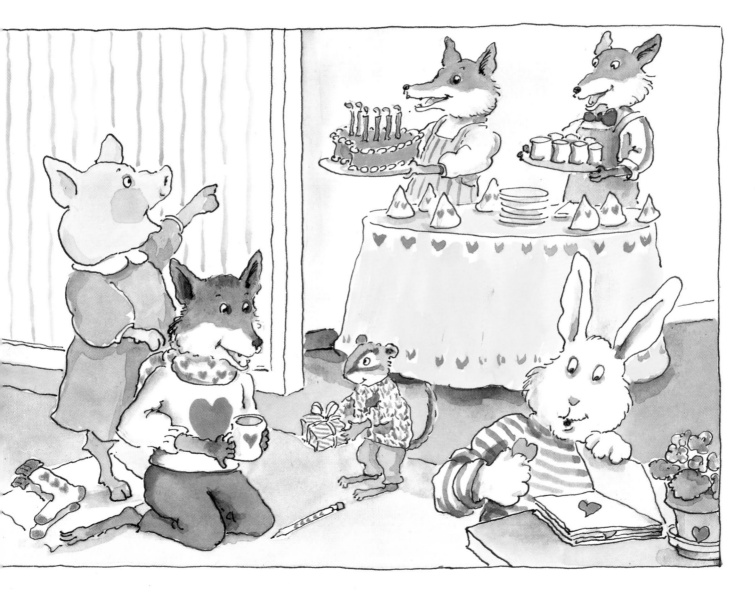

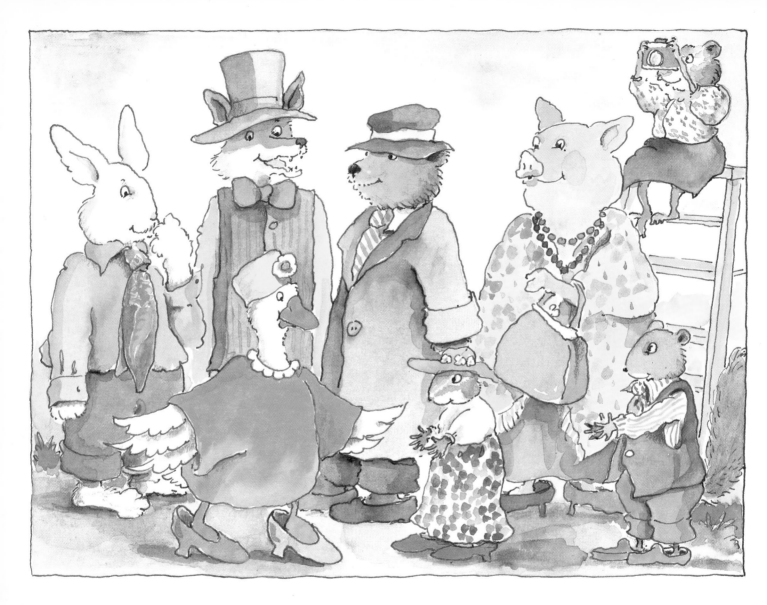

Chipmunk's party—a style show—was in April.
Everyone wore grown-up clothes.

Rabbit helped Chipmunk open the big box of Band-Aids he had given her.

"I hope I get Band-Aids at my party," he thought. He sang his little song to himself. *"Spring, summer, fall. I can't wait for my birthday. I can't wait at all."*

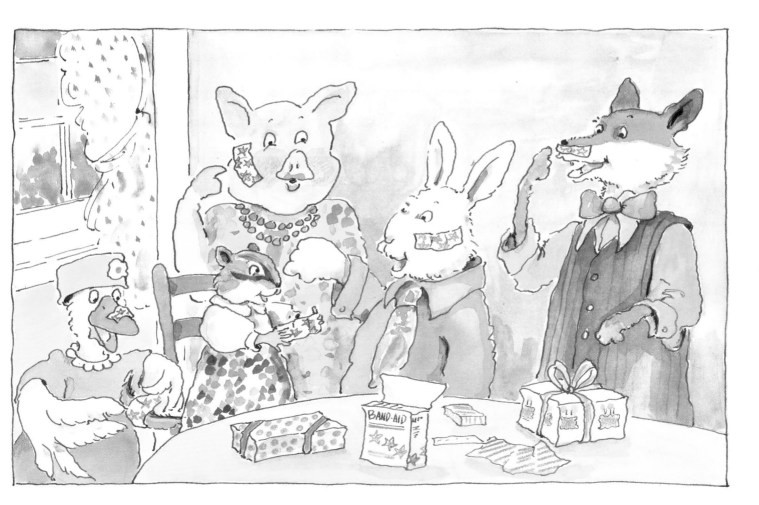

Guess what came in the mail one day in May? A ticket to Squirrel's birthday party—a train ride this time!

"M-m-m," said Rabbit. "Could be fun." He almost forgot he didn't like other people's birthdays.

At the party Mother Squirrel punched each passenger's ticket.

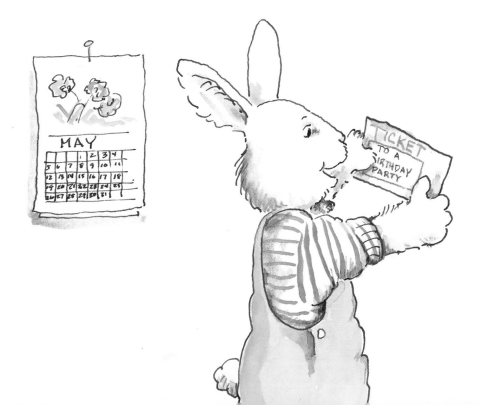

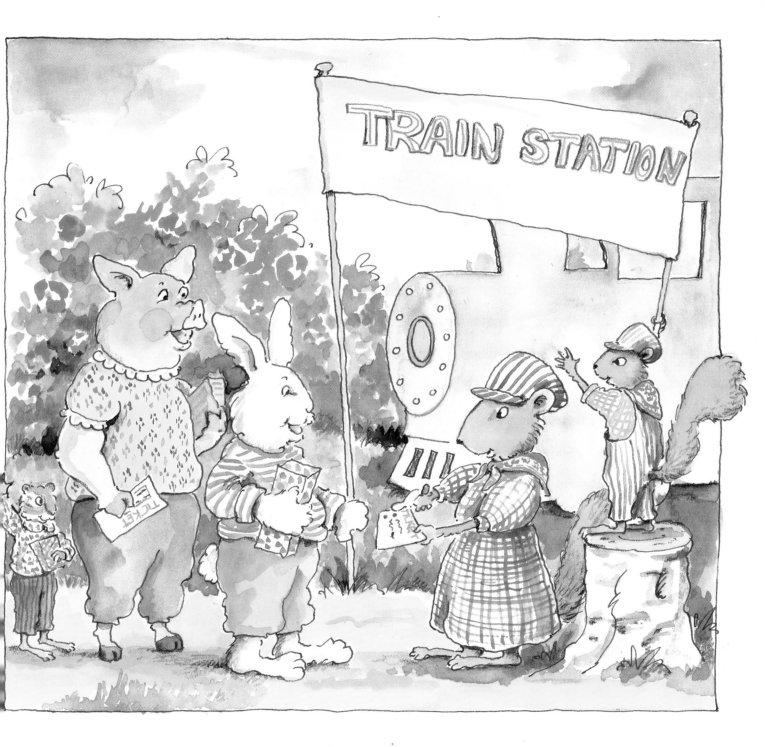

Uncle Squirrel was the conductor. He walked down the aisle with an engineer's cap, a red bandana, and a whistle for each guest.

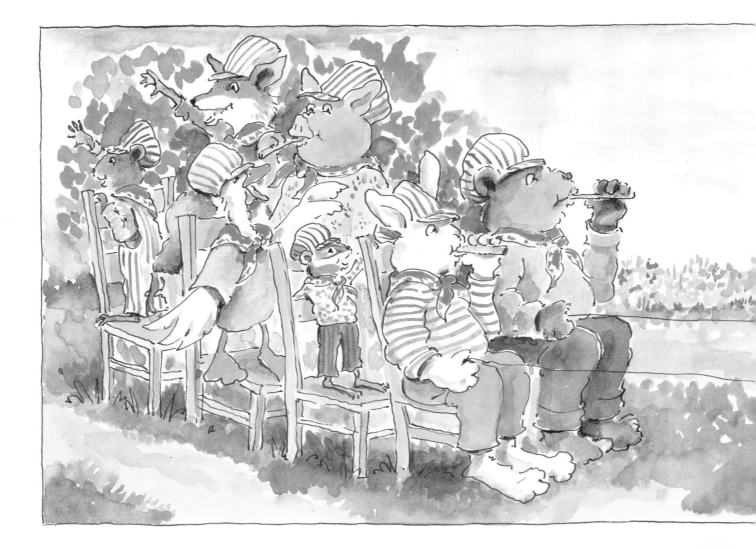

Uncle Squirrel called out the names of the train stops.
At each stop everyone blew his whistle loudly. There
were many stops.

Then Grandmother Squirrel served her delicious nut
cake.

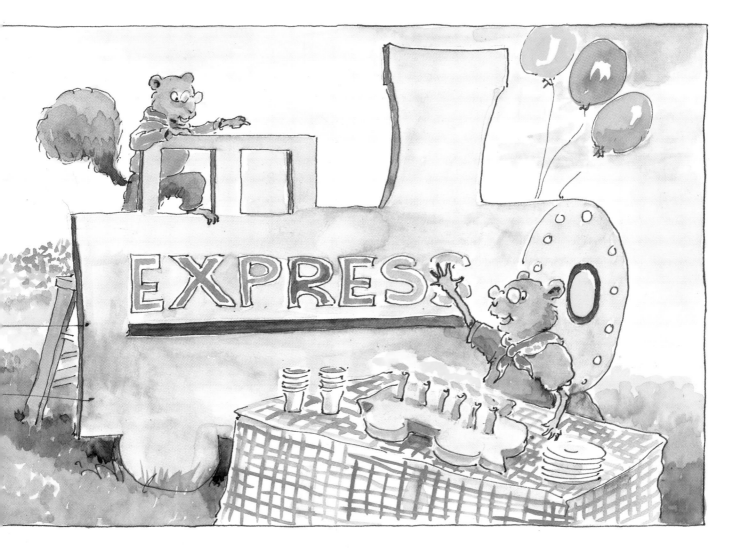

"Will it *ever* be my birthday?" thought Rabbit.

Summer came. *"Summer, fall. Summer, fall. I can't wait for my birthday,"* sang Rabbit. *"I can't wait at all."*

Duck's birthday party was in June. Outdoors, of course. First the guests sprayed each other with plastic bottles full of water.

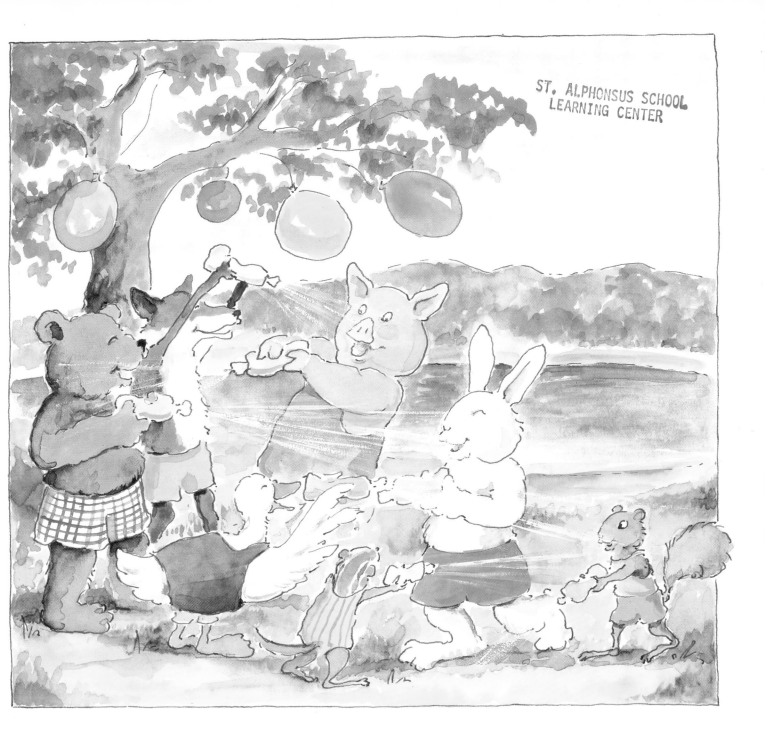

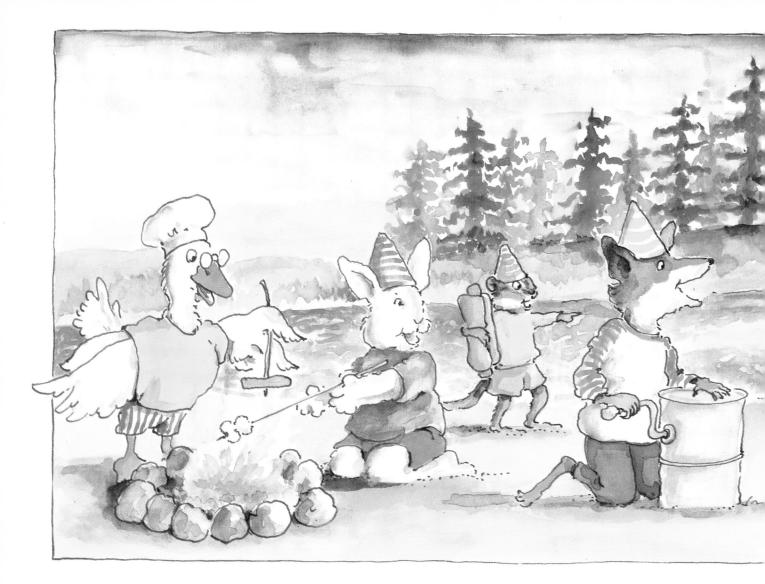

Then they roasted hot dogs and marshmallows over
the fire Grandfather Duck had built. They all took turns
turning the ice-cream freezer.

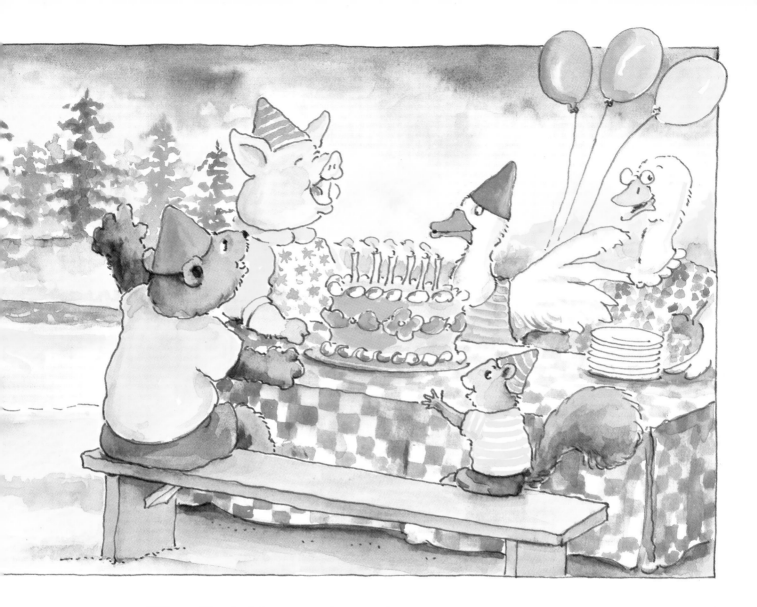

When Duck blew out the candles on her cake,
everyone else sang, "Happy bird day, dear Duck. Happy
bird day to you."

"I can't wait another day!" thought Rabbit.

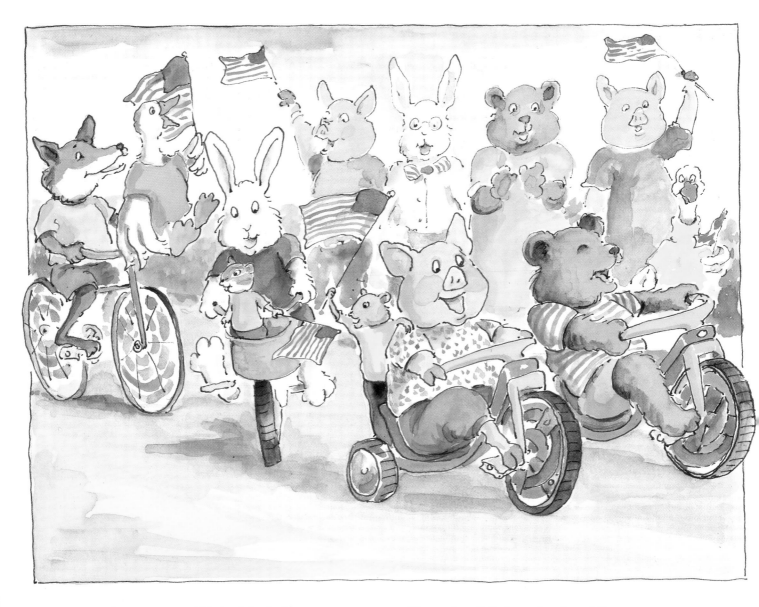

Pig's birthday party was a Fourth of July picnic. All the guests tied red, white, and blue streamers on their bikes for a parade.

Then they went swimming.

"Next party is my party," Rabbit sang happily to himself.

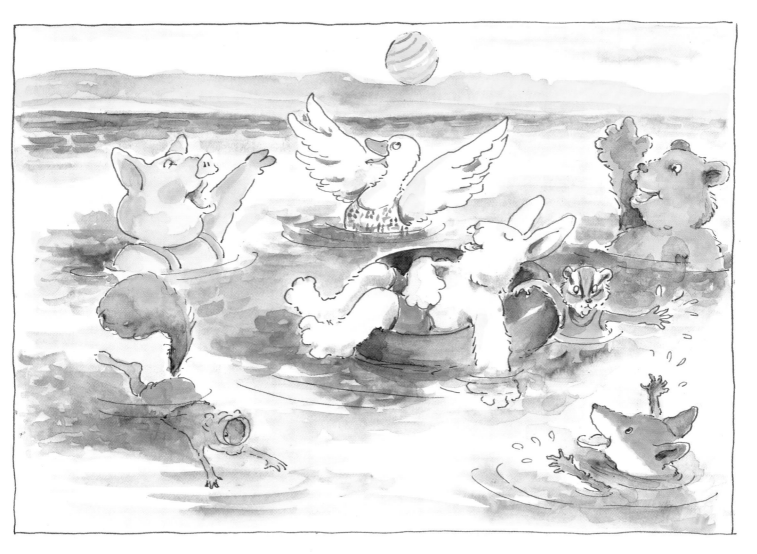

Fall came. "Almost time for you-know-what," Rabbit said.

"All right, Bunny Boy," Mother Rabbit said to him one morning. "We have lots of work to do to get ready for that birthday party of yours. Let's start hopping!"

"Hooray!" shouted Rabbit.

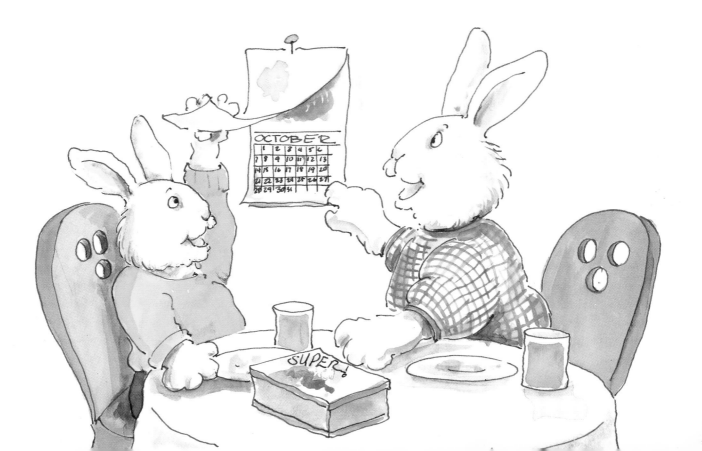

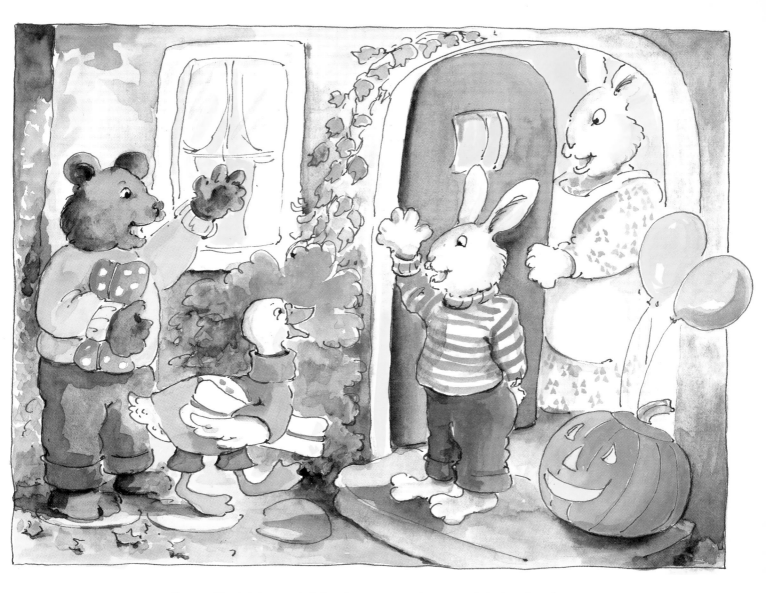

Soon Rabbit and Mother were busy with invitations, decorations, and refreshments.

Party day at last!

First the guests played pin-the-hat on the witch.

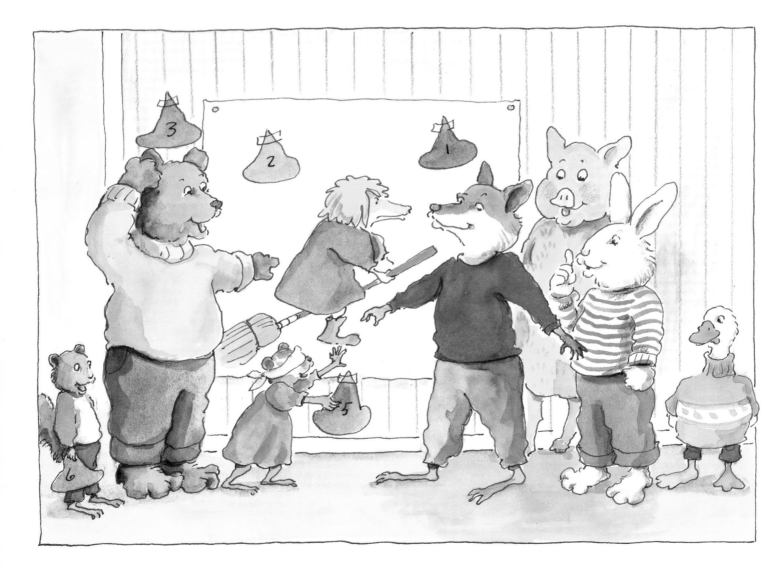

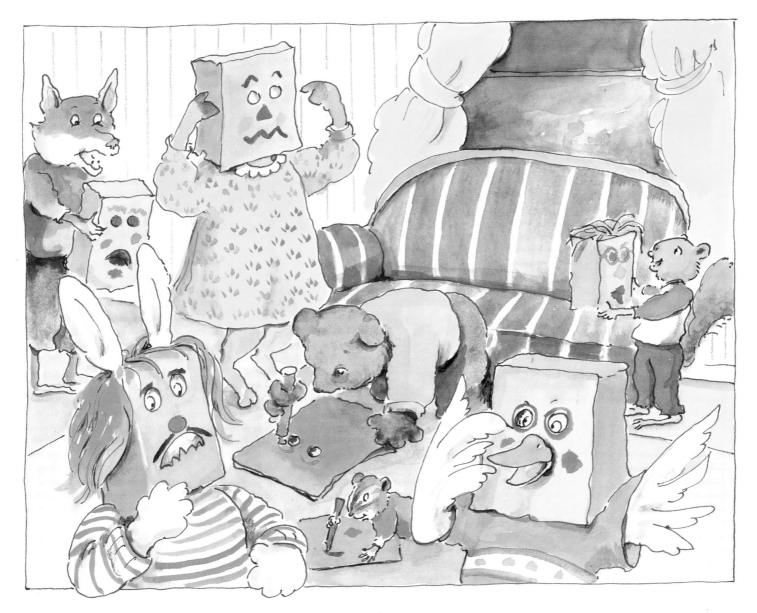

Next they made masks out of grocery bags.

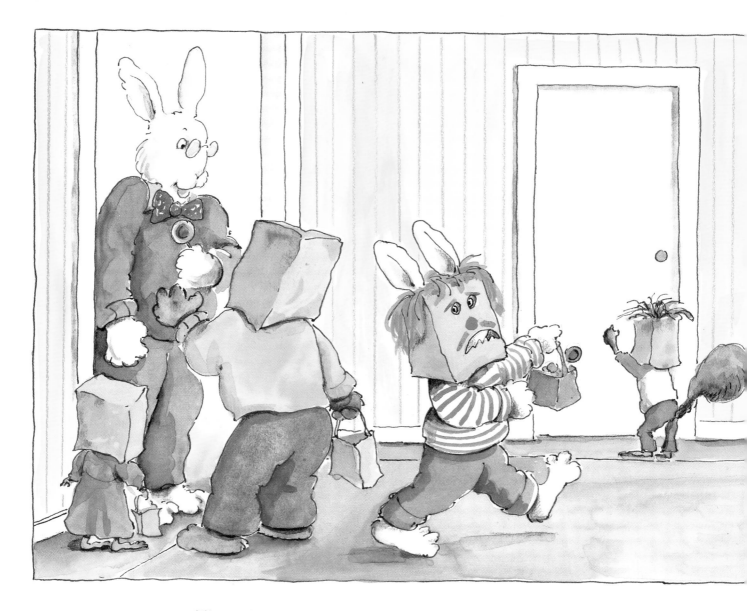

Then they all put on their masks and went from door
to door inside the house. They knocked on every door.
"Trick or treat!" they called.

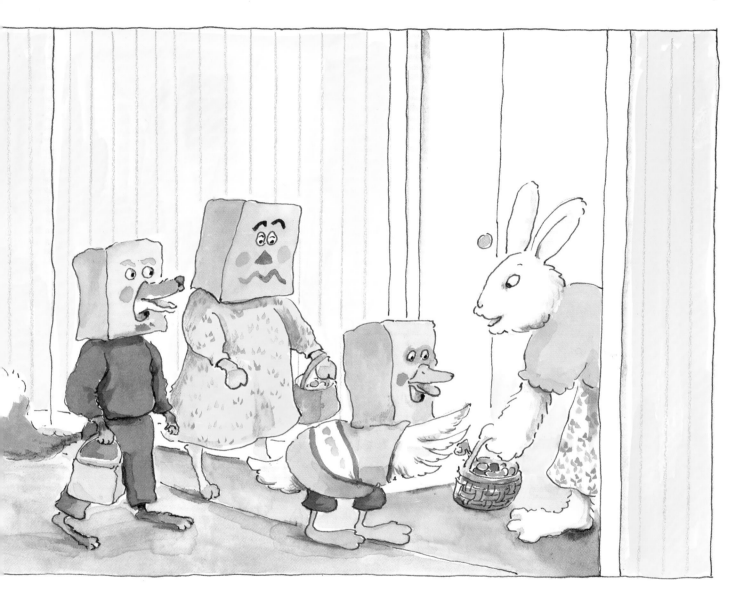

And at every door they got good things—magnets,
magnifying glasses, bubble pipes.

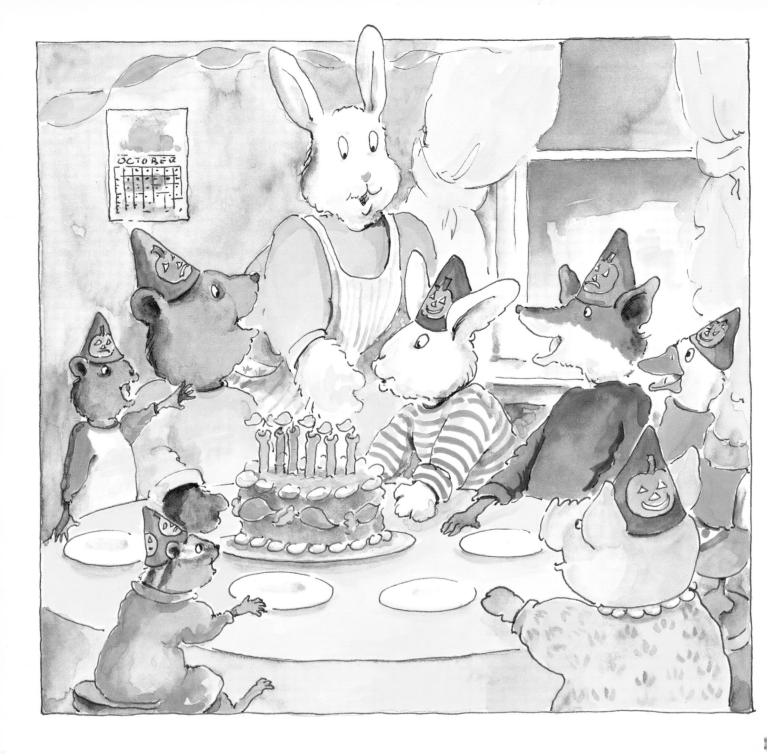

Mother Rabbit brought out her scrumptious carrot cake. Everyone sang, "Happy birthday, dear Rabbit. Happy birthday to you."

Rabbit got the most wonderful presents. Squirrel and Chipmunk gave him a real tool box with real tools and real nails *and* a creepy rubber spider. Pig gave him stationery with his name on it. Fox gave him a rubber name stamp and ink pad. Bear and Duck gave him a backpack *and* fangs made out of wax.

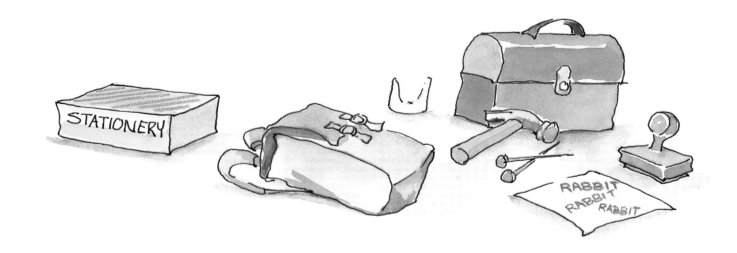

"Everybody else can have a party now," said Rabbit happily. "I had mine."

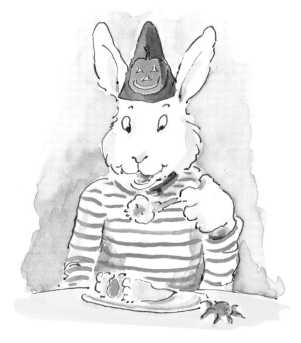

And at the next birthday party, Rabbit was the very first one to sing "Happy Birthday."